Published 2016 by DCD Design, LLC
1920 E. Dale Street, Colorado Springs, Colorado, 80909, U.S.A.

Marketed and Distributed by Satiama, LLC, dba Satiama Writers Resource.
www.satiama.com

ISBN: 978-0-692-64941-1 Library of Congress Control Number: 2016905031

Story and Paintings by Dianna Cates Dunn
Book Design by Julia McMinn Evans
Editing by Karen Stuth, Satiama Writers Resource, and Jill Spear.

PRINTED IN CHINA

ΦDCD DESIGN, LLCΦ

Distributed by Satiama
www.Satiama.com

The Truths of Tula

A Muse and Her Artist

Dianna Cates Dunn

Dedication

To my family, Colin, Carin and Wayne, Sylvia and Ken, and Kathleen and Barney who have been there as Theo was for Vincent......my art would not exist if not for love like yours.

I also want to give my deepest thanks to the following people
who brought this book into life:

Karen Stuth of Satiama Writers Resource, who made what seemed impossible, possible.

Julia McMinn Evans, whose knowledge of the graphic arts laid the vision to beautiful pages.

Gwen Fox, who patiently mentor my growth as an artist through life's trials and tribulations.

Jill Spear, whose editorial guidance and patience deserve more than I can ever repay.

Mary-Linn Benning, Margarete Seagraves, Barbara Blake and Julia, who have championed
what I do and who I am.

Acknowledgements

This publication would not have been possible without the generous support of the following:

Diane Lauren	Marion Meyer	Kelly Sullivan	Prince H. Dunn
Rhonda Miracle	Raymond Webb	Judy L. Kinder	Kay Orgil
Bob North	Diane Pool	Joan P. Murphy	Gail Weber
Carol A. McIntyre	Wendy Dokos	Debbie LaBarre	Laura MacIntosh

A special thank you to each of you.

Musings about Muses

Inspiration comes, inspiration goes. That is the reality for the majority of people regardless of occupation. However, I do think that those involved in the arts are a tad more sensitive to its ebb and flow.

Since the beginning of my own love affair with the arts as very young child, I heard tales of the 'artist's muse' but I didn't have any experience with a personal one. Those stories shaped how I defined the artist's muse. I believed the muse must be an extremely sexy female artist's model or femme fatale that only visited male artists. Unfortunately, I was really only aware of, or taught about male artists. Women were generally missing from art histories or relegated to its footnotes.

But I am not here to talk about these inequities. I am here to introduce you to my first muse! She made her appearance in my studio through an abstract painting I was struggling to complete. Others saw her presence before I did. Once I recognized her, I allowed her to give me a true inspirational push.

Please meet Tula.

Over the many months since Tula has made her home with my family and myself, I have made the following observations about her. She is tender but not overly delicate, confident but not over bearing, a curious and pretty darn fearless being. She is a dreamer and a doer, highly respectful of others and a positive thinker who looks for the potential in all life.

When it comes to her looks, Tula is not a great beauty but doesn't consider herself ugly. As a matter of fact, the plainness of her features never causes her any concern. She knows she is like all women in that she is like no other woman at all. Having very subtle features allows Tula to hope that all women may see something of themselves in her. But no matter how others may perceive her, her looks never affect the effectiveness of what she does. It doesn't matter to her what others may think as Tula is an independent woman living life on her own terms.

The question arises: is Tula me? To that I would have to say a big "maybe." I come from family rich with history of amazing women. Several months and several Tula paintings after I began what Tula inspired, I realized Tula's hair-do looks suspiciously like my maternal Norwegian grandmother's hairdo in a glorious early twentieth century photo now hanging in my home. Although I never met my maternal grandmother, as she died before my birth, my mother and uncle told stories of her intellect, love, courage and housekeeping skills. Oh, and you should know that the name 'Tula' is not a family or known name to me. Discovering her in that first painting, Tula told me her name. Only then did I trace it origins.

Apparently several cultures have derivatives of the name Tula but the Norwegian meaning struck home for me. Tulla- spelled with a double L- means "small woman." Although I am nearly 6 feet tall, I've always marveled that my glorious grandmother was just 4′11″.

So yes, it seems that Tula came in part from grandmother and in part from places yet discovered. We invite you to join us on our journey.

Tula Brings Tea

Tula is a wonder.
Unflappable, all knowing, all caring,
there's little she can't do and even less she won't put her hand to.
When needed, she is there.

Everyone should have a Tula in their lives.

As parents, siblings, and even children, we are often called upon to care for and sometimes even make important decisions for another. Although I view it as a great honor, the giving of care can become a difficult burden. So difficult, that the caregiver sometimes needs a caregiver.

This is the painting in which Tula first appeared. I was working with an abstract idea and didn't even see her beginning to appear. That required the eyes of four other artists with whom I meet with for critique sessions. However, once brought to my attention, I decided to allow her to develop. I have little doubt that she came to me as a caregiver of my own.

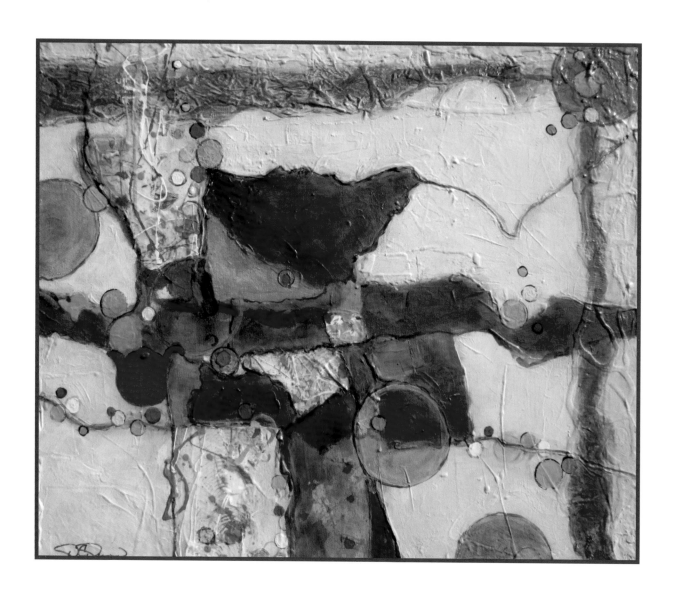

Tula Brings Tea 20" × 24" acrylic/collage on canvas

Tula Teaches Archery

Tula has surprising expertise.
Slings and arrows may come her way,
but Tula takes it all in her stride.

Tula's faith in herself is unshakeable.

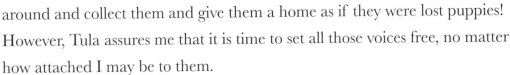

Self-doubt is possibly the most debilitating condition that assails the creativity development and output of any person. Where do all those little voices in our head come from, anyway? I don't believe we are born with them. I sometimes wonder if, as a little child, I just didn't go around and collect them and give them a home as if they were lost puppies! However, Tula assures me that it is time to set all those voices free, no matter how attached I may be to them.

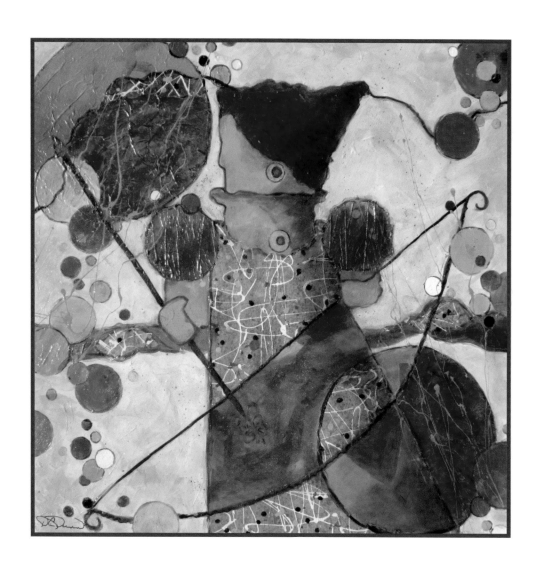

Tula Teaches Archery 30" × 30" acrylic/collage on canvas

Tula Tales

Tula is an avid reader.

There is much to be loved and learned in books.

Tales that are tall and those that are not so tall are to be shared.

Minds that are closed can be opened.

Tula makes and takes time each day to read.

Next to language and visual art, the written word is the most amazing thing ever developed in the human experience. I can't imagine what my world would consist of if I didn't have access to the ideas, stories and the 'vacations' I find in books.

Tula Tales 30" × 30" acrylic/collage on canvas

Tula Toils in the Soil

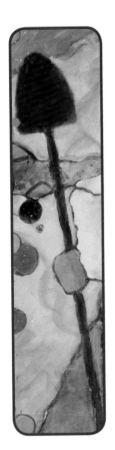

Tula loves to provide.

There is joy to be had in the garden and Tula knows that.

No time spent digging in the dirt is ever time wasted.

For Tula, the earth is life itself.

Tula knows helping other life flourish provides for her own growth and nourishment.

Planet Earth is truly the mother of all life. Mankind, contrary to the practice of some, was not given dominion over her to greedily use and abuse, but rather to be her guardian and protector. There is a special magic that happens when I spend time in nature. I love to grow and tend plants, but the greatest joy comes from learning about and appreciating what the Earth has already provided.

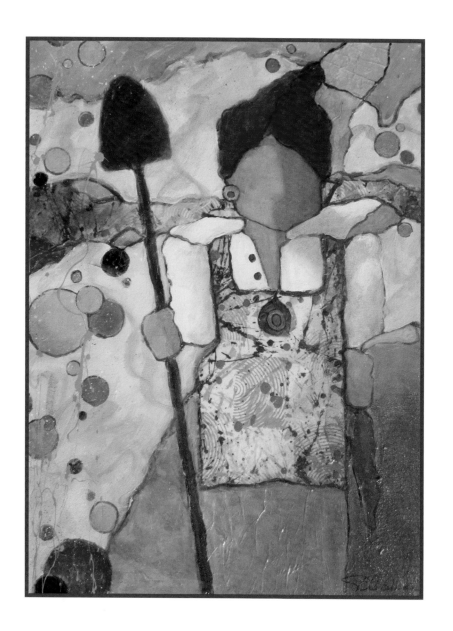

Tula Toils in the Soil 24" × 18" acrylic/collage on canvas

Tula at Twilight

Tula knows when to rest.
After a full and busy day,
reflection is called for.
Self-appreciation and relaxation
are to be enjoyed.

Tula takes care to care for herself.

I often forget the lesson of loving myself. It is much more difficult to praise and appreciate myself than it is to praise and appreciate others around me. But until we each learn to appreciate ourselves, it is almost impossible to establish and maintain personal boundaries. Yet, without personal boundaries, burnout of one sort or another is inevitable.

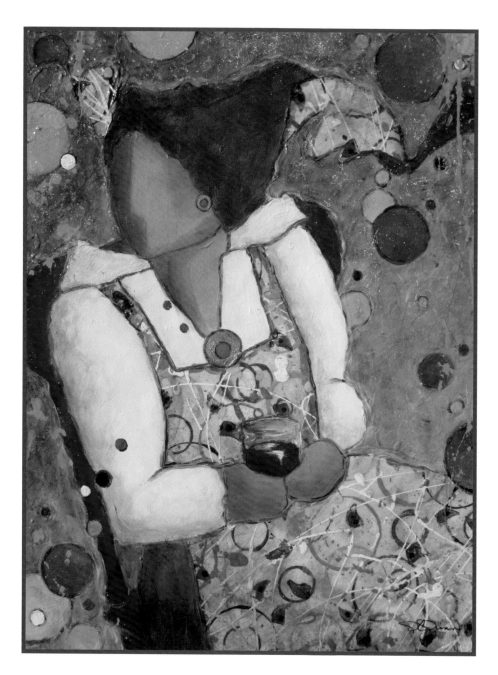

Tula at Twilight 18" x 24" acrylic/collage on canvas

Tula Sets Sail

Tula enjoys exploring the world.
Exotic ports of call beckon her.
Her quest for adventure and learning never ends.

Tula believes that with travel comes understanding and respect for all.

Travel on the proverbial 'slow boat to China.' gets me out of my daily comfort zone and allows me to experience how other people approach life in a way I never would have considered. Seeing ten cities in just as many days has never appealed to me. I'd much rather have ten days in just one foreign place in order to absorb just a bit of how life there is truly lived.

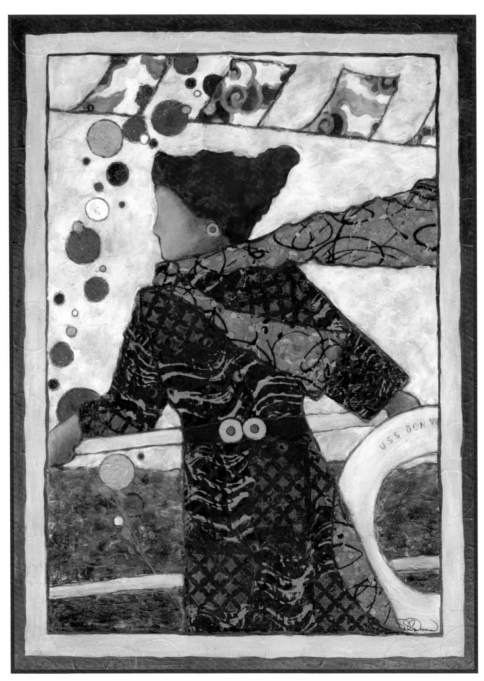

Tula Sets Sail 40" × 30" acrylic/collage on canvas

Tula Takes Telluride

Tula's soul seems to come alive in the mountains
where springtime means meadows of wildflowers.
Summer brings camping and hiking in the pines.
And winter? Well, that means skiing!

Spending time in nature brings Tula a sense of wholeness.

I am often asked if I am a 'mountain' or a 'beach' sort of person. Coming from the Rocky Mountains of the American west, I am very much a 'mountain' sort. But it matters not your preference; what matters is that your inner being is drawn to a natural landscape that is bigger, wilder and more natural than where most of us live our day-to-day lives. There is untamed power in the great outdoors and I find my inner being recharged when I am there.

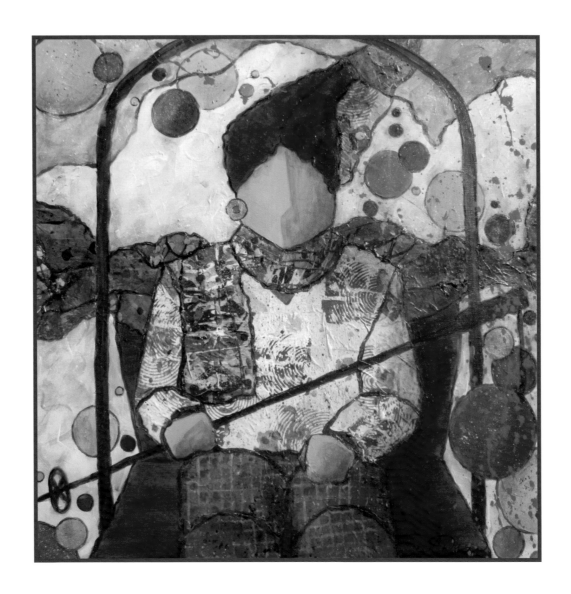

Tula Takes Telluride 24" x 24" acrylic/collage on canvas

Tula Poses for Her Portrait

Tula feels good when looking her best.
Not one to follow fads,
Tula relies on quality and classic design in her clothing
and on her smile for beauty.

Waste not, want not is a truth for Tula.

During my life I have lived in varied situations. I rented a room in someone else's home, lived in a posh high-rise apartment in a big city, restored a historic stone farm home into a bed-and-breakfast and had multiple homes in suburban and urban locals. Through it all, I have come to realize that 'keeping it simple' makes me happiest. Not caring what the Jones, Smiths, or in-laws may think or about having all the latest gadgets, cars or club memberships keeps my focus clearer and my options far more flexible. And, yes, I even think that living simply makes me beautiful.

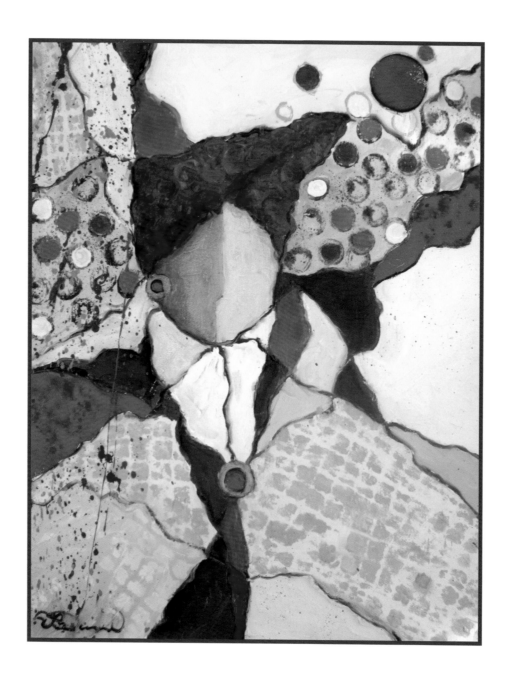

Tula Poses for Her Portrait 14" x 11" oil on canvas

Tula Contemplates Her Work

Tula is very creative and thoughtful.
Finding ways to express herself connects Tula
to all the possibilities life offers and
provides her reason to rise each day.

Tula finds purpose in all that she creates.

I have a belief that all of us come into this world carrying a seed of passion. That seed gets planted and starts to sprout at a very young age, and, if nurtured, grows and blooms quickly. I also believe that in those early years it is easy to squelch or misdirect that growth. Yet, without passion we often become purposeless, though we may not even recognize that as the root of our unhappiness. I found my passion of purpose again and Tula helps me express it.

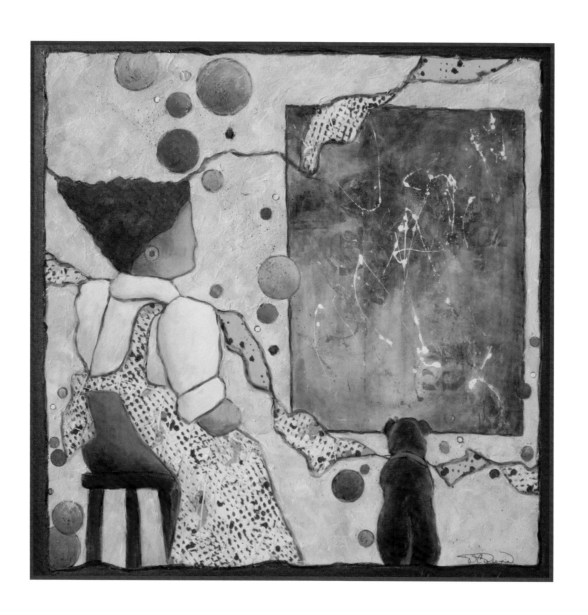

Tula Contemplates Her Work 36" × 36" acrylic/collage on canvas

Moma's Bed is Best

Tula loves Dory the dog.

The joy and complete adoration Dory returns cannot be duplicated.

Tula often thinks that God is spelled backwards, and

many have agreed.

Tula is blessed by the love of animals around her.

 This is Dory, my real life companion and model. Half Sharpei and half Border Terrier, Dory came to me as rescue dog about the same time Tula entered my life. Now "who rescued whom" is still subject to debate but no one can ever love you as much as your dog does! She also loves Tula and enjoys appearing in paintings with or without her.

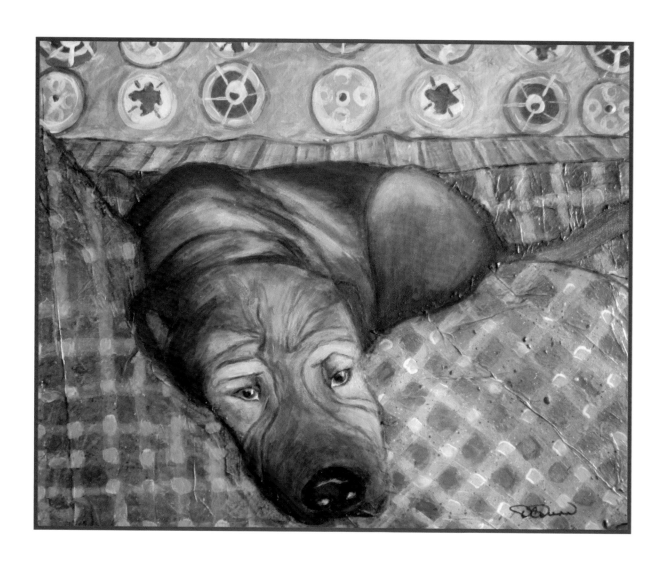

Moma's Bed is Best 16" x 20" acrylic/collage on canvas

Tula Walks With Jenny

Jenny the mule is one of Tula's great friends.
The affection and care they give one another is unquestionable.
Their bond goes beyond words and comes from the heart.

Spending time with animals provides Tula a connection to all life.

Without our connection to others, life would be impossible. Even if it were possible it would be an unbearably lonely place. With connection comes the responsibility of learning how to be respectful and caring, which gives one far more than it ever takes. Without it, complete connection to ourselves can never be achieved.

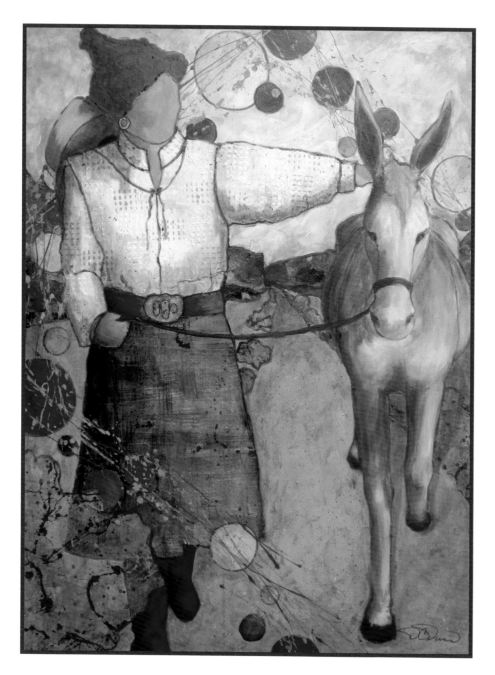

Tula Walks With Jenny 48" x 36" acrylic/collage on canvas

Tula and Sven Tango

Tula finds joy in so many things.
Dancing a mean tango brings her delight
and well-deserved attention.
Friends like Sven never tire of her company.

Tula cherishes her good friends.

Without my friends my life would be a hollow and empty existence. They are oars to my dingy, the salt and seasoning of my food, the hankies that catch my tears, the mirrors of my soul and the counselors without whose wisdom I cannot exist.

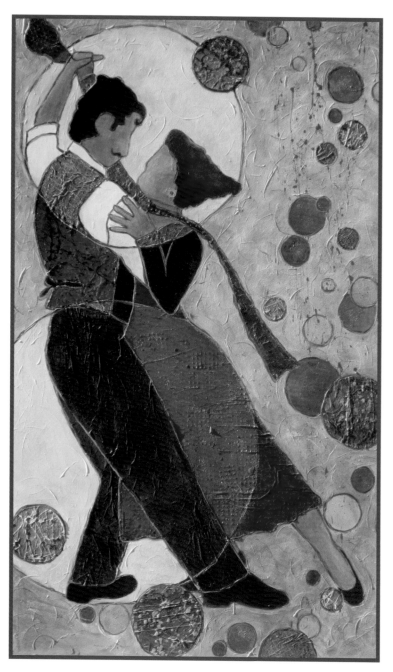

Tula and Swen Tango 60" × 36" acrylic/collage on canvas

Tula Greets the Bees

Nature in all its variety fascinates Tula.
Knowing that all forms of life are interwoven together
motivates Tula to be a gentle caregiver to all.
Bees make her marvel at life's generosity.

Tula's life is but one small part of the natural whole.

As I continue to observe and contemplate life in all its complexity, I am
continually amazed at how intricately all the bits and pieces from the
tiniest molecules to the unfathomable enormity of galaxies are woven
together and work together.

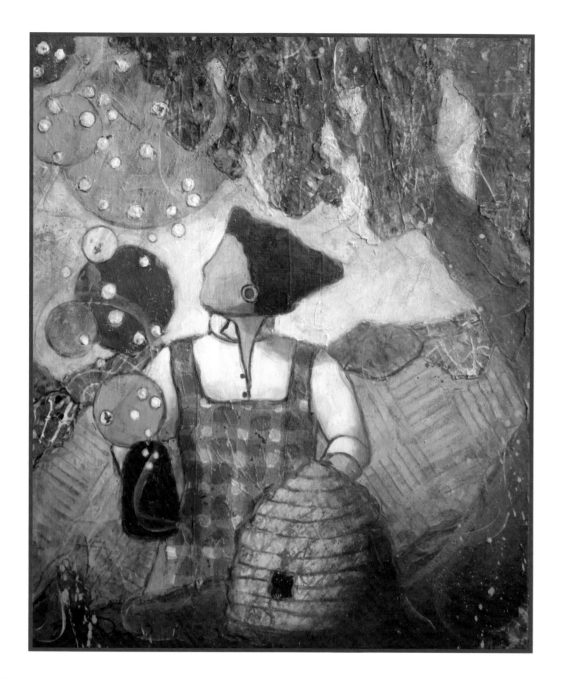

Tula Greets the Bees 24" × 20" acrylic/collage on canvas

Tula's Opening Night

All the arts intrigue Tula.

Whether it be music, stage, film or visual art,

she invites them to engage her mind and stretch her ideas.

The arts enrich her understanding of life.

Tula knows the arts provide the deepest form of communication.

Life without communication isn't. And even if it was, would I want to live it? I must communicate effectively to connect with life, to make friends, to express my appreciation and to share my passions. Our senses are all wired to our brains in order to better express and enhance the communication experience. We watch, listen, touch, and even smell our environment in order to enhance our ability to communicate. Elevating communication to an art form provides a reason for all life.

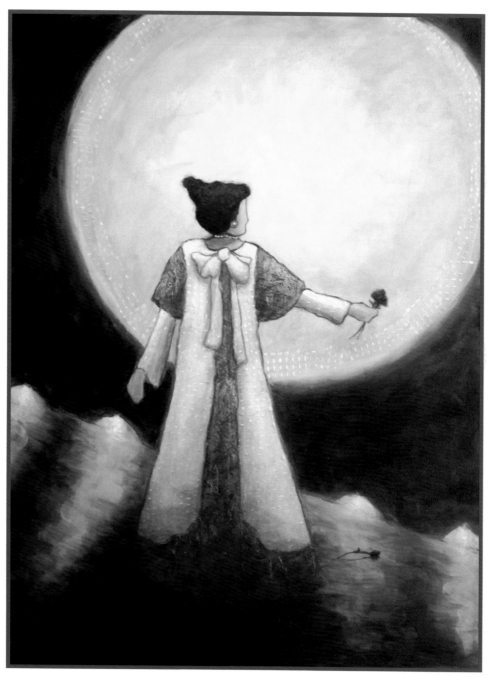

Tula's Opening Night 40" × 30" acrylic/collage on canvas

Tula and Lily Learn

Tula loves to learn.
Making time to be with children is a priority,
allowing her to share in their wonder and their wisdom.
This is a gift only children can give.

Tula knows that children make the best teachers.

Being with children can often make me reach into neglected corners of my mind. Often, long forgotten thoughts and ideas get dusted off for new inspection because of a child's insight. It reminds me that wisdom isn't always learned; sometimes it's just been forgotten and needs to be rediscovered.

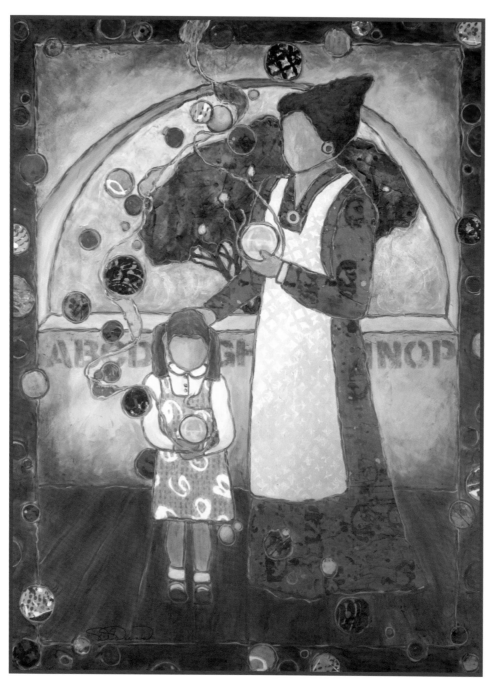

Tula and Lily Learn 48" x 36" acrylic/collage on canvas

Peaceful Night

Tula knows the golden ratio applies to many things in life. It provides the delicate balance between the energy of day and a night filled with peace.

Tula knows that in order to thrive life requires a finely-tuned balance.

For much of my life, I approaced balance as a novice might approach walking a tightrope. I was full of tension, dread and filled with thoughts of the impossible. After all, I had so many responsibilities, so many people to please and so many things that I needed to accomplish that finding a 'seat at the table' for my own needs was just too much to ask! That is how my days played out right up until I broke. Only in losing my ability to run and accomplish did I discover the power of balance. Now my inner needs share equally with others at my proverbial, personal table.

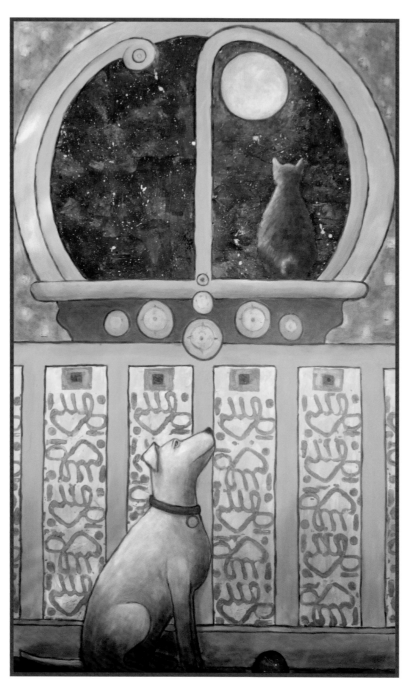

Peaceful Night 60" × 36" acrylic/collage on canvas

Tula's Saffron Trail

Tula views her life as an amazing journey.
Whether by fate or by choice,
the road she has traveled has been shared
with many others who have brought
support, guidance and, best of all, love.

**In the end, we will be remembered by
the love we give.**

A journey into solitude brought me the knowledge that, no matter where I am, I am never truly alone. Perhaps that is because I have been given the gift of love and have chosen to embrace it. Love in all its forms and from all of its sources sustains me on this sometimes arduous but always remarkable journey of life.

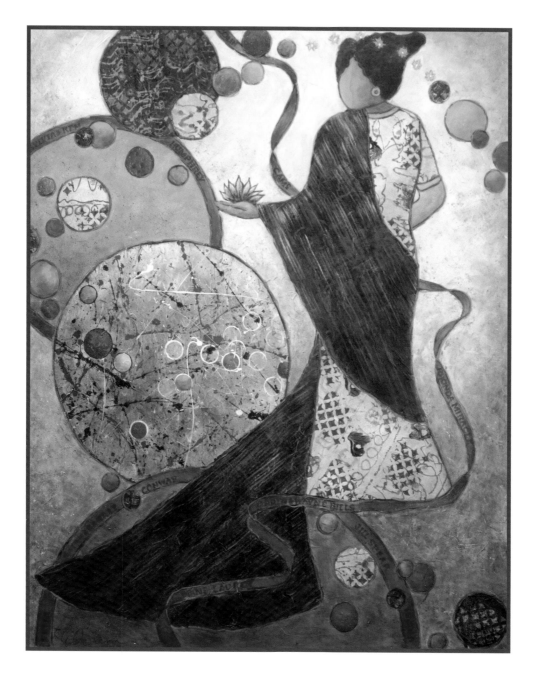

Tula's Saffron Trail 60" × 48" acrylic/collage on canvas

Tula Meditates

Tula finds balance and inner stillness
in quiet meditation.
Deep breaths combined with the absence of thought bring
an inner peace that defies reason or season.

Tula believes that strength and direction
come from within.

In my middle years, I came to discover that I really didn't know who and what "I" was! My culture never encouraged a discovery that looked inward, pointing me instead to the people, places and events that surrounded me in order to define who "I" was. I just ended up feeling confused and highly inadequate in all ways. Not until I discovered how to regard and appreciate what was inside of me did I discover who I am and who I might become.

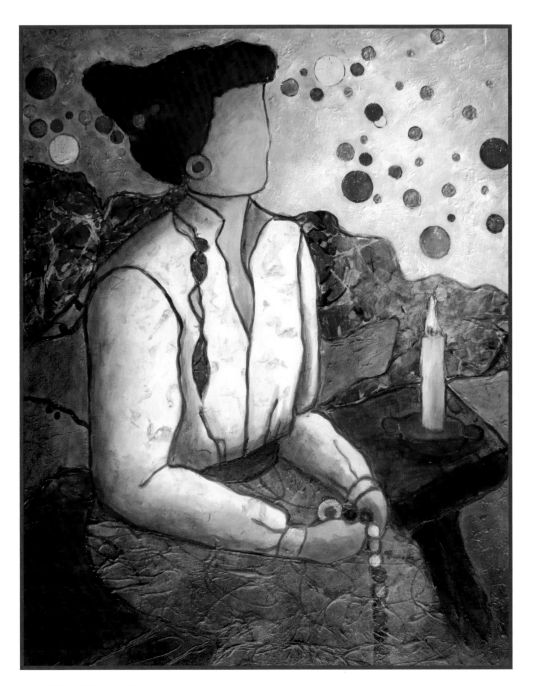

Tula Meditates 28" x 22" acrylic/collage on canvas

Tula Touches Home

The world amazes Tula.
Vast, yet vulnerable, the Earth and its capacity to shelter
life touches a tenderness in her heart.

There is truly no place like home.

The world encompasses me and enables me. Its beauty inspires me; its power humbles me. To me, the world is a living, breathing, life-filled entity in and of itself. It does not need humankind, but it does allow humankind to share in its life-giving bounty. The world is not a judgmental entity, but an entity with a myriad of naturally occurring checks and balances that keep it healthy and alive. If the world is healthy, then I can be filled with health and if the world, my home, is not healthy, then neither can I tap into complete health.

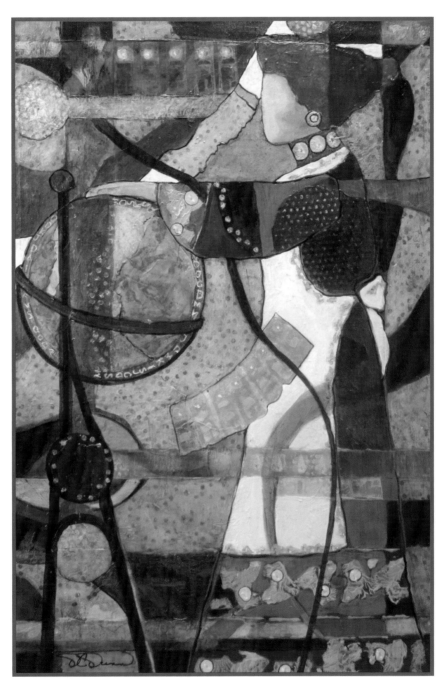

Tula Touches Home 36" x 24" acrylic/collage on canvas

Tula Loves Sven

Tula practices loves.
Opening your heart to another is
a miraculous, wondrous thing.

Tula teaches us that love, in all its forms,
connects us to life.

I believe we all have tender souls. We are so
tender that, at very young ages, we start to
learn how to protect ourselves from sometimes
thoughtless, sometimes intentional wounding.
Having a sometimes guarded soul is sometimes a
wise thing, but putting too many guards in place
may lead to a form of self-imprisonment and loneliness. Trust in
yourself and know that there is strength in sharing tenderness.

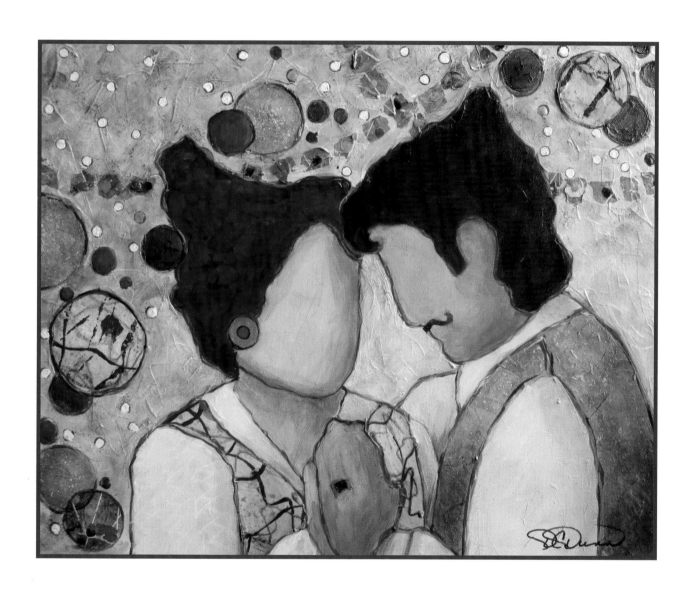

Tula Loves Sven 16" x 20" acrylic/collage on canvas

Index

Original art may be purchased at: www.diannacatesdunn.com
Prints may be purchased at: Saatchi.com: http://www.saatchiart.com/account/artworks/422628
www.diannacatesdunn.com

About the Author and Artist

Dianna Cates Dunn is an artist living the western USA who has been blessed with the need to create art. Tula is currently using her to share joy with all those willing to see.

www.diannacatesdunn.com

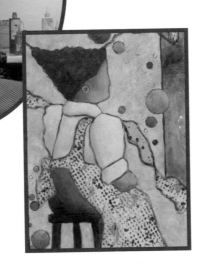

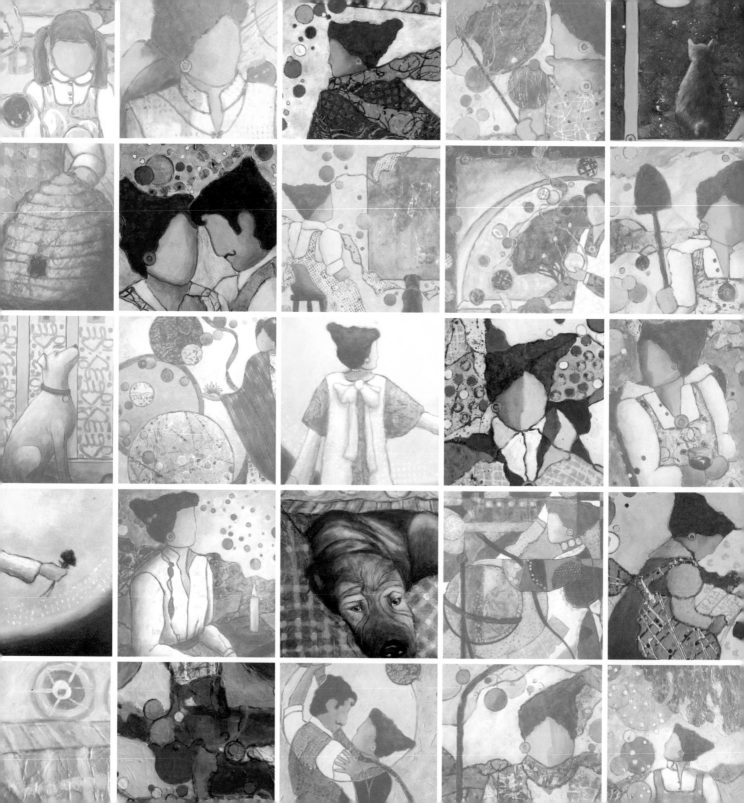